BARBARA MORGAN
PHOTOMONTAGE

BARBARA MORGAN
PHOTOMONTAGE

Published in cooperation with
The International Museum of Photography
at George Eastman House by

MORGAN & MORGAN
Dobbs Ferry, New York

Morgan & Morgan, Inc.
Publishers
145 Palisade Street
Dobbs Ferry, New York 10522

Library of Congress Catalog
Card Number 80-81142
International Standard Book
Number 87100-171-3

Printed in two-impression Quadradot
Lithography by The Morgan Press, Inc.,
Dobbs Ferry, New York

Printed in U.S.A.

Dedicated to Willard D. Morgan

Who inspired me to be
a photographer

FOREWORD

BARBARA MORGAN'S particular strength as a photographer lies in her rich variousness, her "multiplicity" as she would say, the ability to throw her arms around life. This openness and over-riding humanity are felt in all her work but especially in the photomontage which has provided her a visual sounding board for both her concern with social issues and her abiding interest in rhythm, design, and movement.

Although better known for her dance photography and such books as MARTHA GRAHAM: Sixteen Dances in Photographs (Duell, Sloan, and Pearce, N.Y. 1941) and SUMMER'S CHILDREN (Morgan & Morgan, Scarsdale, N.Y 1951), her interest in photomontage began with her switch to photography from painting in 1935 and never declined. It exists concurrent with pictures of her children, portraits of friends, and nature studies.

A recurring technique, which has intrigued such predecessors as O.J. Rejlander, H.P. Robinson, John Heartfield and Moholy-Nagy, allows the photographer to re-arrange reality by combining two or more pictures into a composition. Time and space can be fractured and rebuilt with infinite variety.

A photomontage by Barbara Morgan is the end-product of a series of complex decisions beginning with the concept. The exposure and selection of the negatives follow, and the design is rendered through such carefully chosen printing procedures as combination printing; sandwiching negatives together, thereby printing them simultaneously; pre-planned double exposure in the camera; the re-photographing of collaged photographs; and/or a combination of the above. The pictures can be appreciated without knowledge of their technical virtuosity. But Morgan's choice of process nevertheless determines the structure of the image which is, in many respects the essence of its meaning. Some insight into the printing methods is therefore helpful for an understanding of her photomontage.

The work is as much about time itself as about the subjects that time intersects. The negatives are generally made at different places and times, sometimes decades apart. When working, she sometimes makes new negatives, sometimes selects from her composite file those which most clearly advance her idea.

When first preparing for this book and her exhibition at the George Eastman House, she noted with surprise that many of her montages were sharply critical or ironic. Many were fashioned in comment on problems of contemporary society. This thread of ethical concern runs throughout her work in such pieces as *"Hearst Over the People, 1938-39," "Pure Energy and Neurotic Man, 1941," "Artificial Life From the Laboratory, 1967,"* and *"Nuclear Fossilization, 1979."*

Pasting a distorted face of William Randolph Hearst onto an aerial picture of a large crowd, Morgan adds octopus-like tentacles which reach even beyond the frame. The picture plane runs at a perilous slant, a subtle piece of wry humor itself.

In "CITY STREET, 1937," the conflicting points create a swirling image of faceless city life. The viewer appears to be looking down from a height as if falling toward the pretzel vendor and the sidewalk below, only to realize that the columns slanting first one way and then another establish a ground-level stance for staring at some anonymous institution. Spatial disorientation has been created by combination printing. As one section of the paper is printed from a negative, other parts of the paper are masked for later printing with another negative.

"FOSSIL IN FORMATION, 1965," announces its intention in the title. The derogatory illustration, prompted by a frustrating day in the city, superimposes the impression made by a prehistoric fossil. This wonder of intricacy and compartmentalization imposed upon a picture of buildings at night, with lights on, reveals hundreds of small divisions but no life. By putting negatives in contact and aggrandizing the scale of the fossil for purposes of comparison, two images separated by millions of years become equivalent. The shell of a snail, not only dead but disintegrated, left behind a radiating spiral design, a vortex which is allowed to comment on the empty regimentation of city life.

In a more light-hearted vein, her fanciful nature and love of form and rhythm are especially apparent in the dance montages and "SPRING ON MADISON SQUARE, 1938."

The previsualized, double exposure of "COWBOY SONG" expresses movement through time. Jose Limon performs a wide-open body gesture in one place which is resolved by a second exposure superimposed at a right angle. The significant phases within the dance are synthesized into a metaphor of the entire dance as they occur.

"SPRING ON MADISON SQUARE, 1938," is a fine example of Morgan's intuitive approach to composition. Pleased by a gift of tulips on a snowy day, she took a picture of the scene outside her studio window. In the darkroom she exposed this negative twice, jarring it slightly to suggest the street movement, then laid two tulips across this and exposed a negative of Eric Hawkins dancing, creating a photogram in the process. She transformed these disparate elements, originally intended for other purposes, into a unified and exuberant expression of Spring.

Barbara Morgan's photomontages surprise and delight us with their juxtaposition of parts, skewed space, range of subject, variety of techniques and active examination of her own time.

Marianne Fulton Margolis
Curator of 20th Century Photography
George Eastman House

INTRODUCTION

My inspiration to create photomontage comes from early root experiences.

At age five, my whimsical-philosophical father, holding a green leaf in his hand, said: "This leaf is not moving, but millions of atoms are dancing inside it, and atoms are dancing in everything in the world!" Then a bird flew into a tree. As we watched, my father said, "Let's see if we can tell when the bird wants to fly." We saw the bird's head jerking, side-to-side, then, crouching, he suddenly flew off into the sky.

My father explained, "Not only atoms dance inside everything, but IDEAS to do things are inside birds, and animals, and people!" Since then, I have always searched for the "invisible urges."

About the same time, a painting by a great-uncle inspired me to start painting, and my parents happily kept me supplied with paints, brushes, and paper. I painted: trees, landscapes, animals, and funny fantasy things as well.

As an adolescent, I also wrote poetry, rather secretly. The verbal metaphors that were in my mind's-eye, were also visual metaphors. So, the visual metaphors of to-day's photomontage are simply a continuance via the photographic medium.

When studying Art at U.C.L.A. 1919-1923, our Art History professor was deeply into Oriental and Prehistoric Art. The ancient Chinese art cannon of Rhythmic Vitality and Japanese Esoragoto (feeling of rapport with the subject) went along with my inner awareness of "dancing atoms" and the visual metaphors, with its similarities to Haiku poetry.

The history of Art created throughout the world, from cave painting days (approximately 15,000 B.C.) to now, reveals the universals of the human psyche, for through time, Painters, Sculptors, Printmakers, and now Photographers, express Realism, Symbolism, Fantasy, Abstraction in their varying styles and media. This revelation hit me while looking at the Lascaux cave painting in France, before the caves were closed. I saw the palimpsest image-overlays, the visionary, pregnant animals, as well as "realistic" animals, plus abstract, symbolic forms. Suddenly, I thought, nothing is basically NEW in Art—only variations on life's fundamental themes through the millenia!

All these experiences were enriching preludes to my later interest in photomontage.

In 1925 while at U.C.L.A. teaching water-color landscape painting, abstract design, and woodcut printing, I married Willard Morgan, then a young writer-photographer. He tried to inspire me to be a photographer, not just a painter—saying, "Photography will be the 20th Century Art and the International Language, because gesture conveys more than words."

Shocked, I responded, "If you just click the shutter, you are stealing from reality! I can't be a thief! I must create!"

Soon after this, a miracle happened. Edward Weston, (then hardly known) was just back from Mexico and was given his first show at U.C.L.A. As the youngest faculty member, I installed exhibits. At the ecstatic moment when I saw his prints, I thought, "Willard is right. Photography can be Art!" While the mechanics and chemistry of photographic technique are essential, it is imagination, via philosophy and esthetics—that are my root inspiration.

Although Weston's images were "reality", they went far beyond in their essentialized, symbolic beauty.

From then on, although I continued to paint and exhibit, I also gladly photographed, but only to help Willard and not as my own expression. I painted and exhibited even after the birth of our first son, Douglas. But by 1935, when our second son, Lloyd, was born, there was no time for me to paint and take care of our children. To seriously photograph, I thought the only way I could be true to my creative imagination was to work with photomontage, and as a mother concerned for the Future, I felt the obligation to express the increasingly complex problems of our World with the hope of inspiring affirmative change.

The following 12 descriptions illustrate the motivation and the technique involved in each of these images.

PURE ENERGY AND NEUROTIC MAN, 1945 © 1972 (photomontage-light drawing) (cover): Having made many rhythmic light drawings, which seemed lyrical and idealistic in contrast to so much of the ego-power struggle in our world, I planned this light drawing, with upper-right empty space, in which to receive the second negative image of the "grabby" hand, shot at 1/10,000th of a second.

CITY SHELL, 1938 © 1972 (p. 15): In New York, 1937, I was looking from my fourth story studio window, admiring the "new" Empire State building, which was then an heroic symbol of "modern man"; when a friend came in with a beautiful shell which we placed on the window ledge.

Suddenly, seeing the Empire State building and Shell simultaneously, I thought: "This Shell is also a Habitat!—the rhythmical creation of an anonymous architect!"

So, I was instantly inspired to create the photomontage and to counterplay the Shell with the geometric Empire State building—which I turned upside down because I felt that the primitive Shell will outlive our man-made Skyscrapers.

MARTHA GRAHAM: Lamentation, 1935 © 1979 (planned double image) (p. 21): While absorbing the sequence of the emotional gestures of Martha Graham's dance, Lamentation, I "saw in my mind's eye" the overlapping emotional transformation: from anguish and utter tragedy, to final acceptance and release.

MARTHA GRAHAM: Deaths and Entrances (group), 1945©1972 (planned double image) (p. 24): The double-image change of scale is to convey the dream-like memory of past loves.

JOSÉ LIMÓN: Cowboy Song, 1944 ©1972 (double image single negative) (p. 27): Because of the explosive joy of his dance, I changed not only the size scale of the two images, but criss-crossed the two, since his intention was to be rambunctiously playful!

In **CORN STALKS GROWING, 1945** ©1979 (p. 35), I wanted to convey simultaneously the exhuberant forms of growth-change of young and older plants, by combining the two images.

BRAINWASHED, 1966©1969-II (p. 38): A local school teacher, distressed by the effect of TV violence on her students, came to discuss her concern, saying—"Our children are being BRAINWASHED!" To put this problem into visual form, I photographed her out-of-focus, and I altered the eye to symbolize distorted vision.

INNER STRATAS, 1970 (p. 41): I enjoyed making visible, the invisible striations of glass via the photogram, and wondered how much of the world's fabric is invisible?

YIN-YANG IN FLIGHT, 1956©1979 (photomontage-photogram) (p. 53): A whimsical simultaneity of opposite forces, was inspired by thinking of the attraction-repulsion of a magnet, and of the Yin-Yang idea of Chinese philosophy.

NUCLEAR FOSSILIZATION, 1979 (pp. 56-57): Two weeks before the Three Mile Island nuclear accident, thinking how life might be changed by nuclear radiation, I had a sudden urge to create different versions of NUCLEAR FOSSILIZATION. I was shocked, but not surprised, when the disaster happened.

SERPENT LIGHT—III, 1948©1979 (photomontage-light drawing) (p. 59) symbolizes the rhythmical urge which I think we share with all animal life, and to which breathing, dancing and music relate.

UFO VISITS NEW YORK, 1965 (photomontage-light drawing) (p. 60) I keep a "Photomontage Component File" of negatives that I feel have a combine-potential. After a whimsical discussion with a friend, about the possibility of UFO's, I suddenly remembered these two negatives which I sandwiched as a photomontage-light drawing.

Barbara Morgan

LIST OF IMAGES

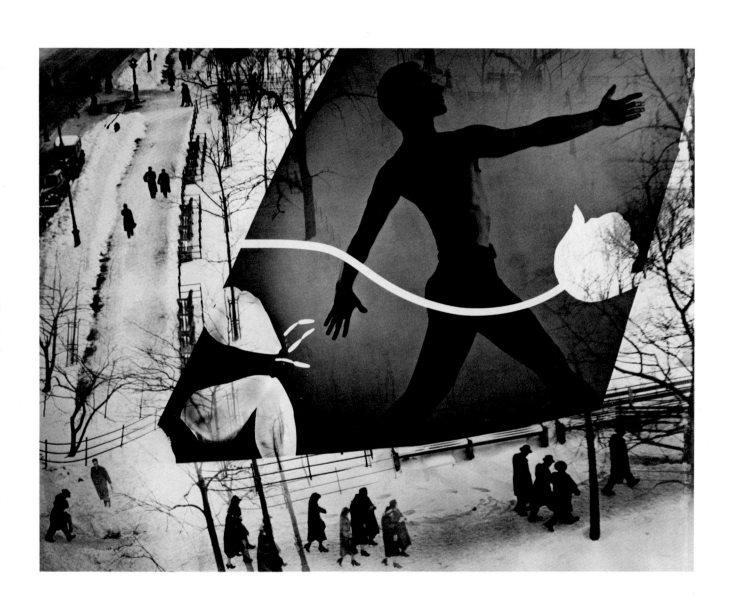

12 *SPRING ON MADISON SQUARE, 1938· © 1972 (photomontage-photogram)*

13 *CITY STREET, 1937· © 1979*

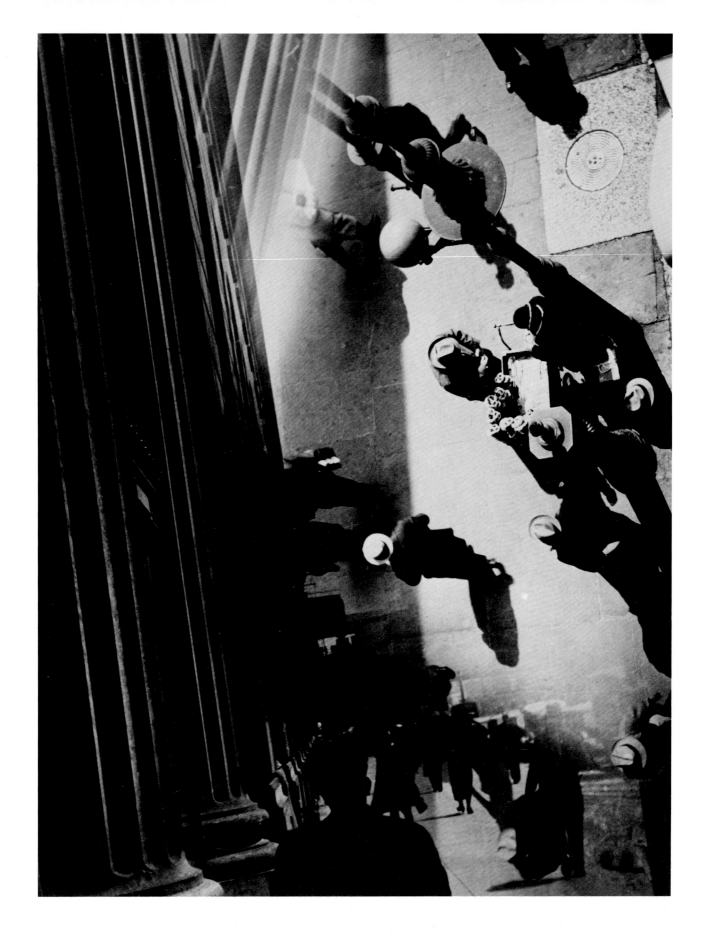

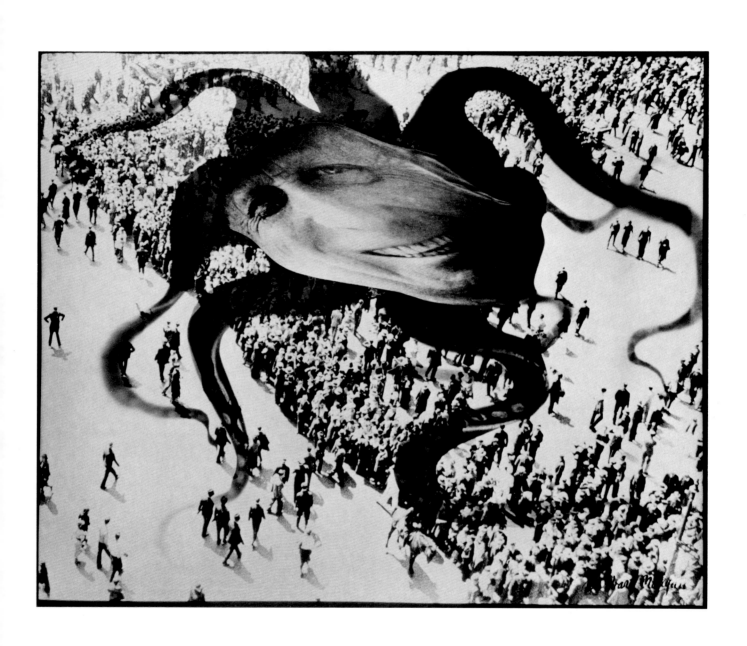

14 *HEARST OVER THE REOPLE, 1939-© 1972*

15 *CITY SHELL, 1938-© 1972*

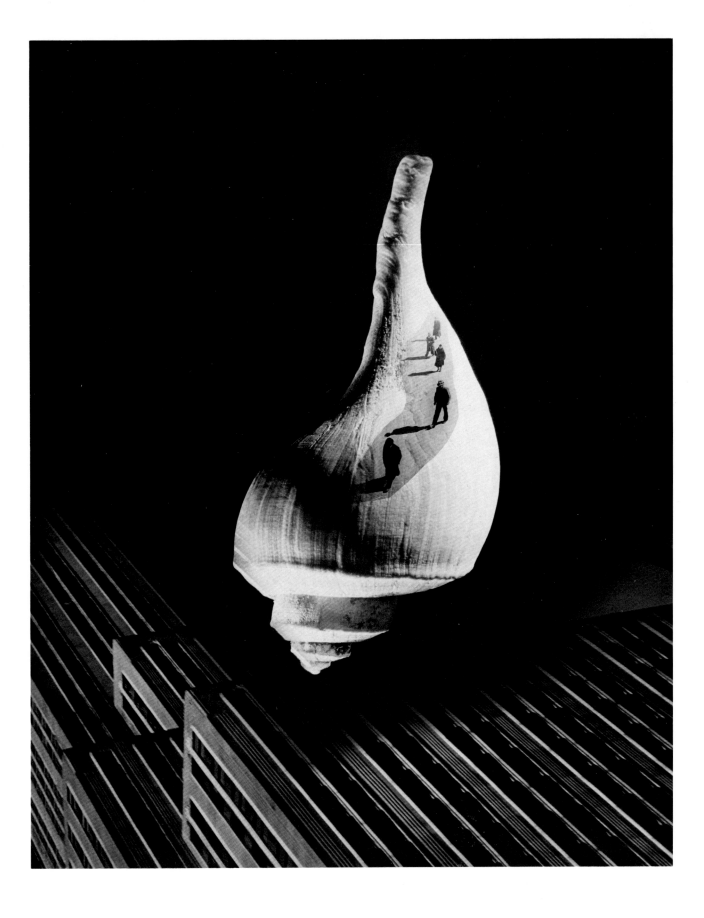

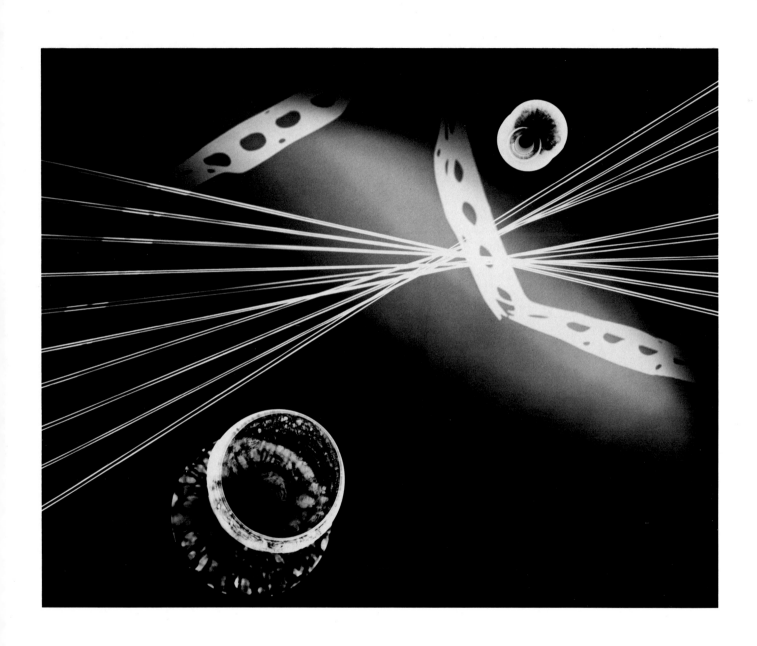

16 *TRANSFERENCE, 1956-©1971 (photomontage-photogram)*

17 *THIRD AVENUE EL, 1936-©1979*

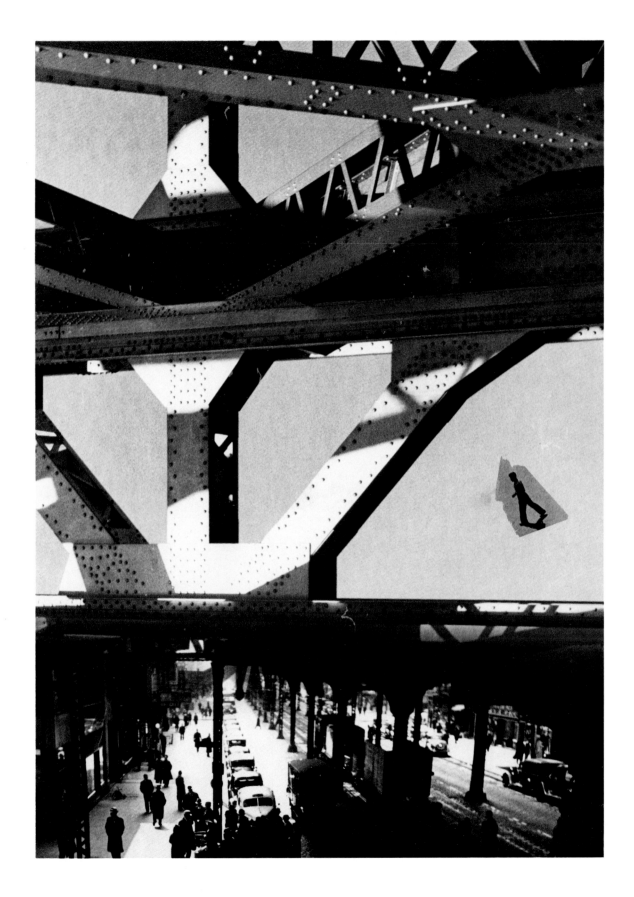

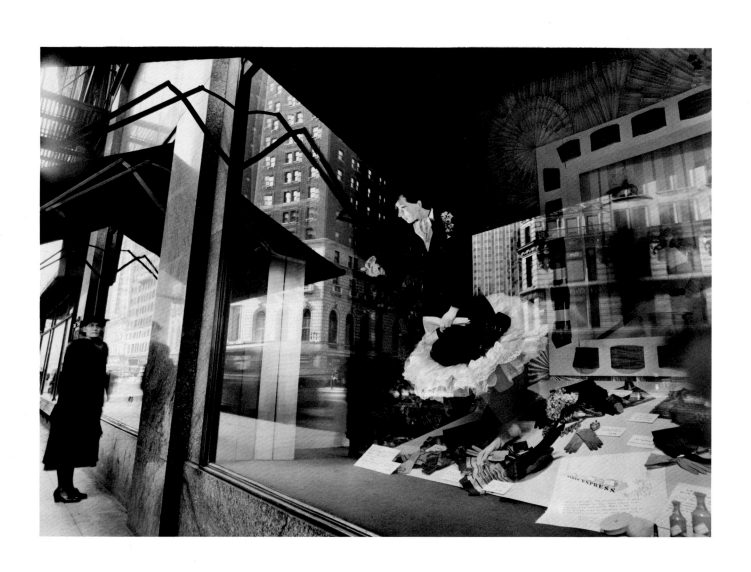

18　*MACY'S WINDOW, 1939·© 1972 (natural photomontage)*

19　*CONFRONTATION, 1970*

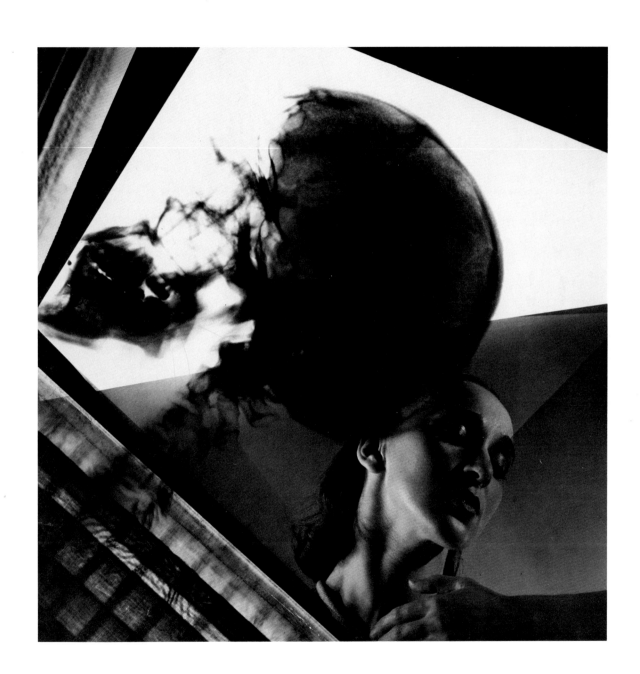

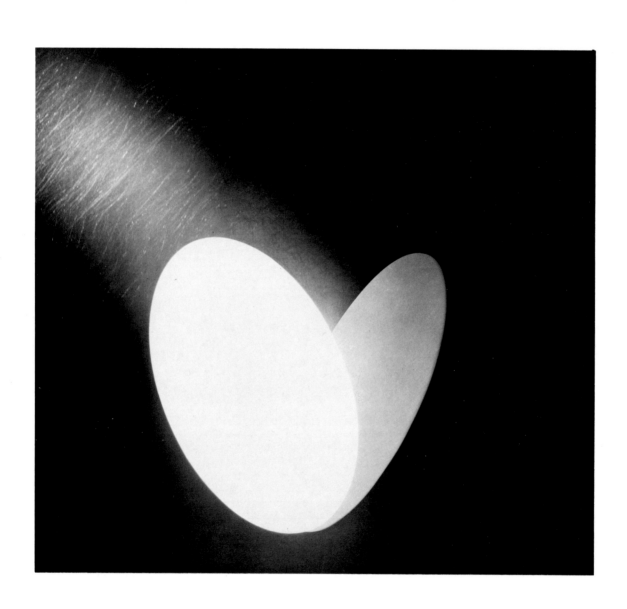

20 *EMERGING, 1979 (photomontage-photogram)*

21 *MARTHA GRAHAM: Lamentation, 1935-©1979 (planned double image)*

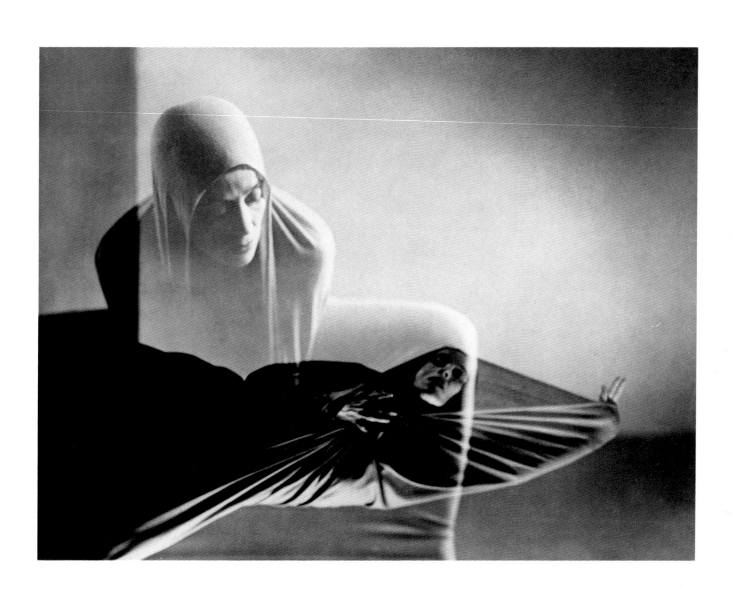

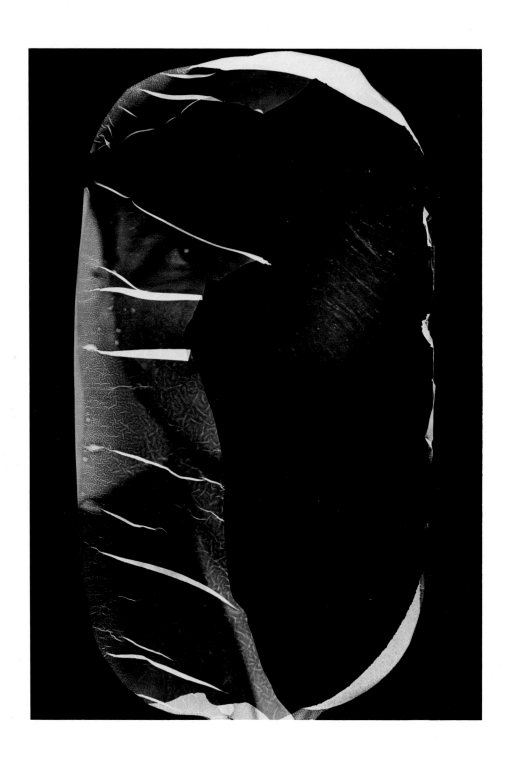

22　*RETICULATE, 1960·©1978*

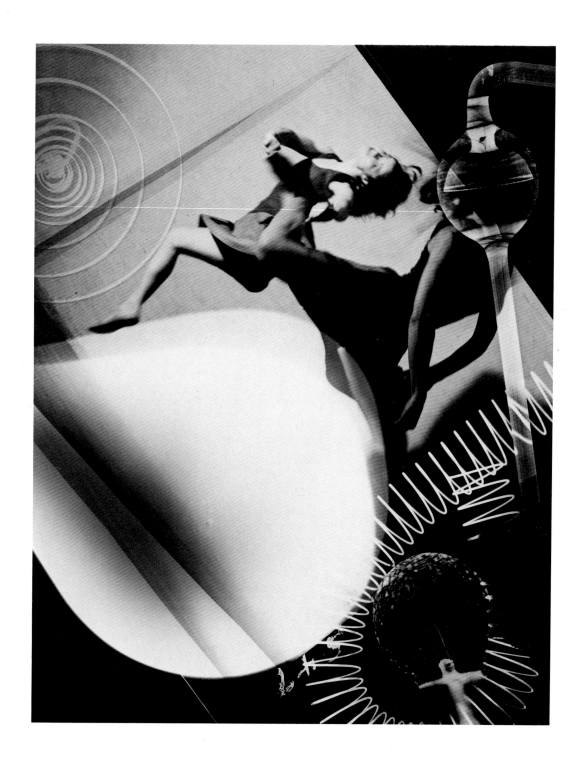

23 *FROLIC IN THE LAB, 1965-* © *1979 (photomontage-photogram)*

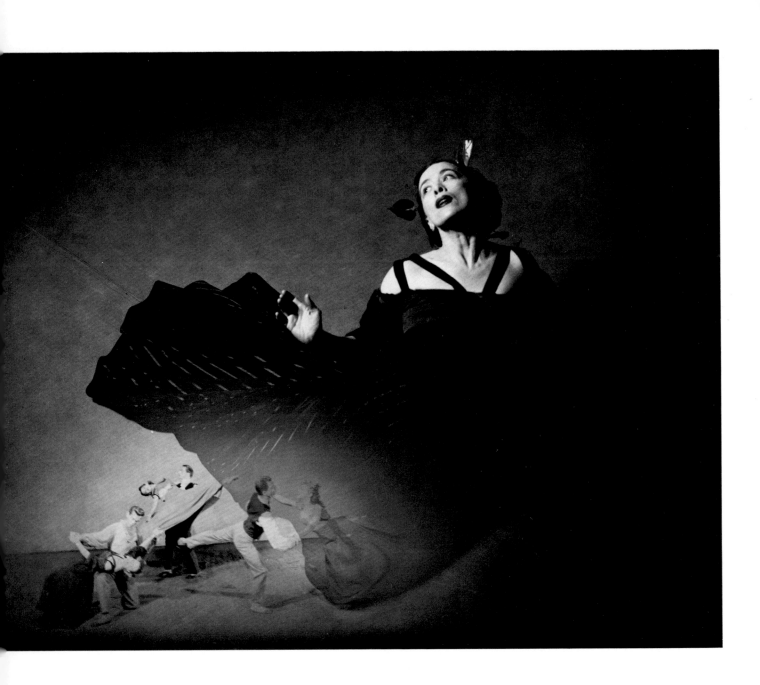

24 *MARTHA GRAHAM: Death and Entrances (group), 1945-* ©*1972 (planned double-image)*

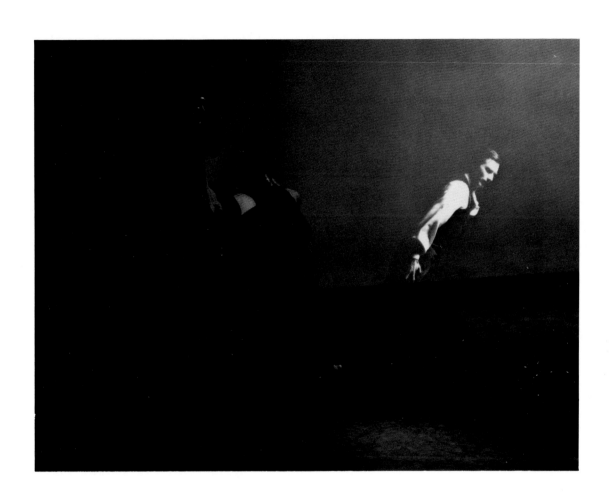

25 MARTHA GRAHAM: Deaths and Entrances, 1945-©1972 (Departure of lover with Hawkins)

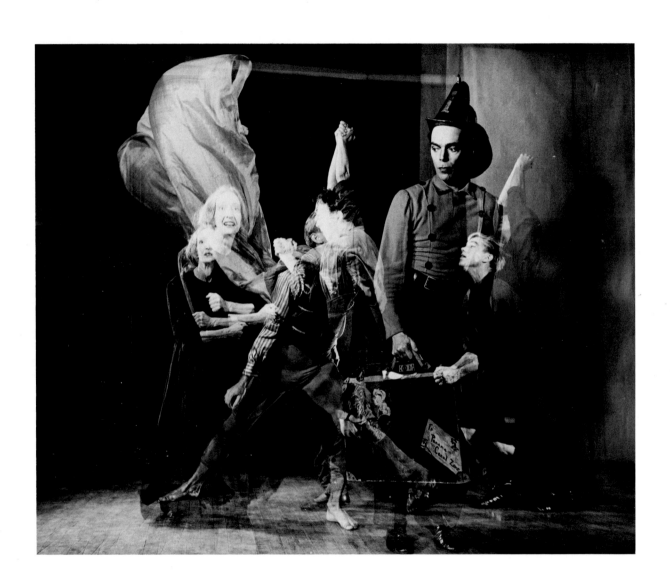

26 *HUMPHREY-WEIDMAN: Rehearsal Nightmare, 1944-©1978*

(planned double-image) (Humphrey: ''Inquest''-Weidman: ''Daddy Was A Fireman'')

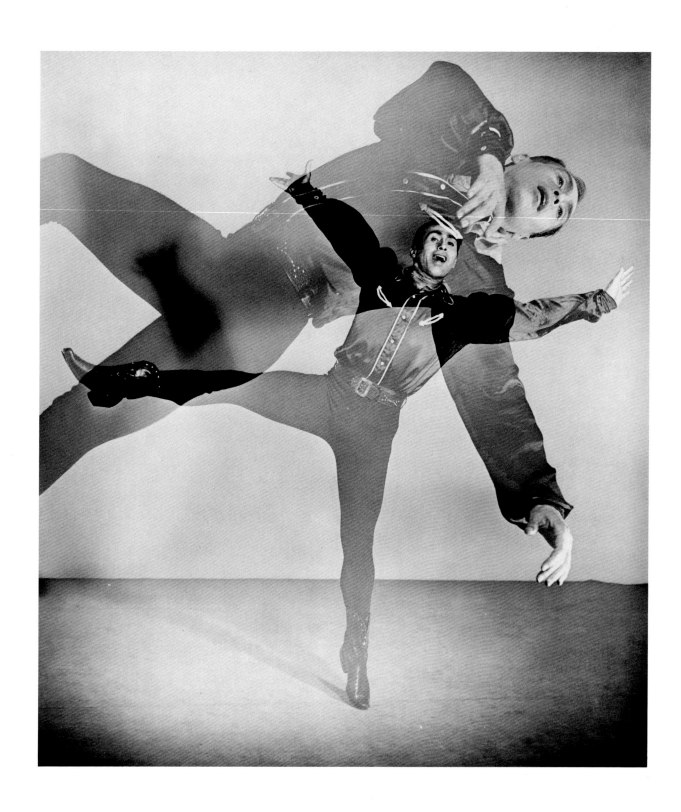

27 *JOSÉ LIMÓN: Cowboy Song, 1944·© 1972 (double image single negative)*

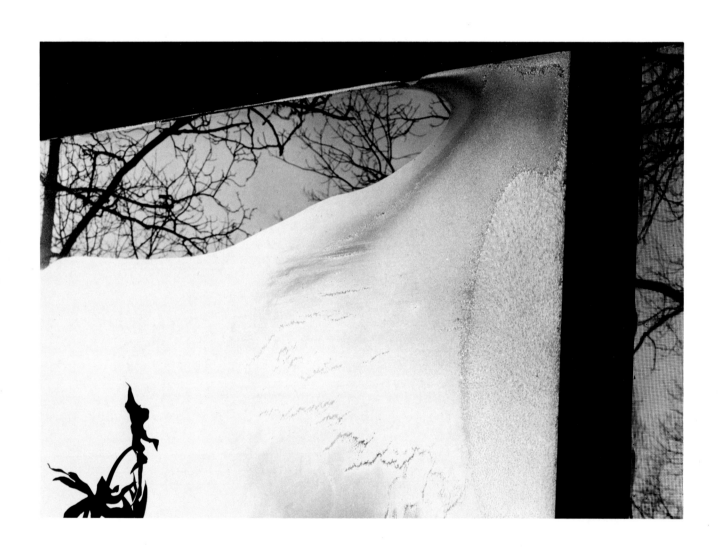

28 *SAETA: Ice on Window, 1942-©1972 (natural photomontage)*

29 *SOLSTICE, 1942-©1972 (natural photomontage)*

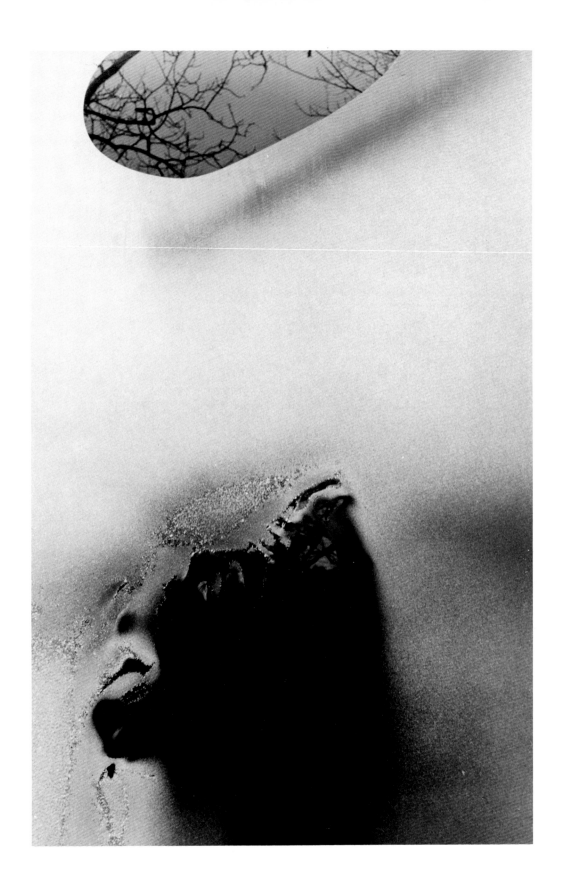

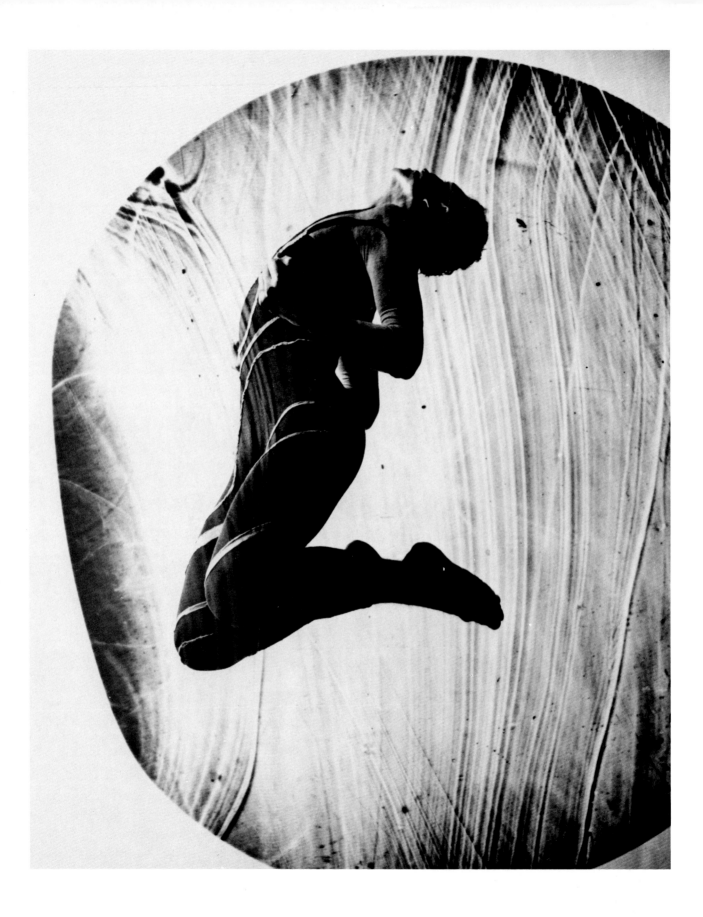

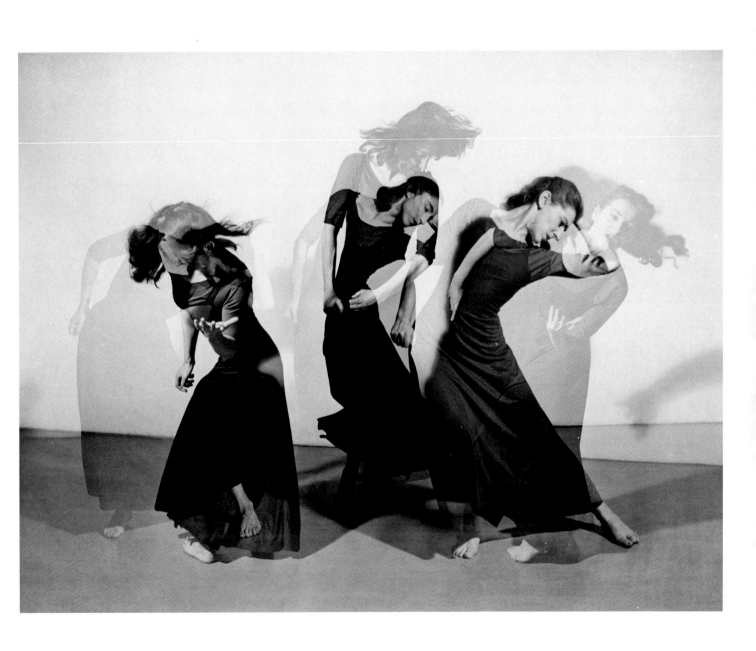

30 *EMERGENCE, 1979*

31 *MARTHA GRAHAM: American Document (trio), 1938-©1979 (planned double-image)*

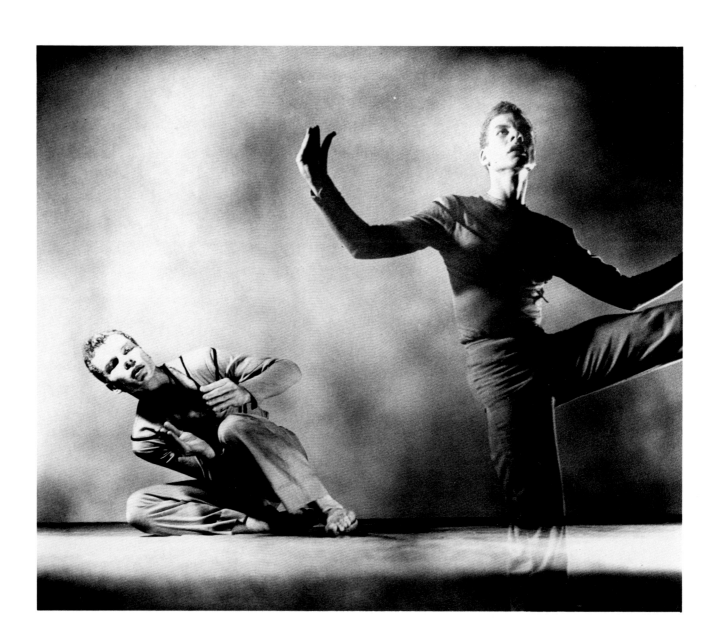

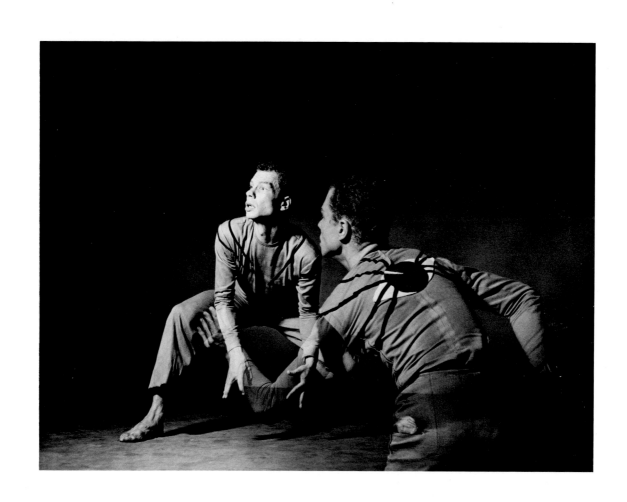

32 *MERCE CUNNINGHAM: Root of The Unfocus-II, 1944-© 1979 (planned double image single negative)*

33 *MERCE CUNNINGHAM: Root of The Unfocus-I, 1944-© 1979 (planned double image single negative)*

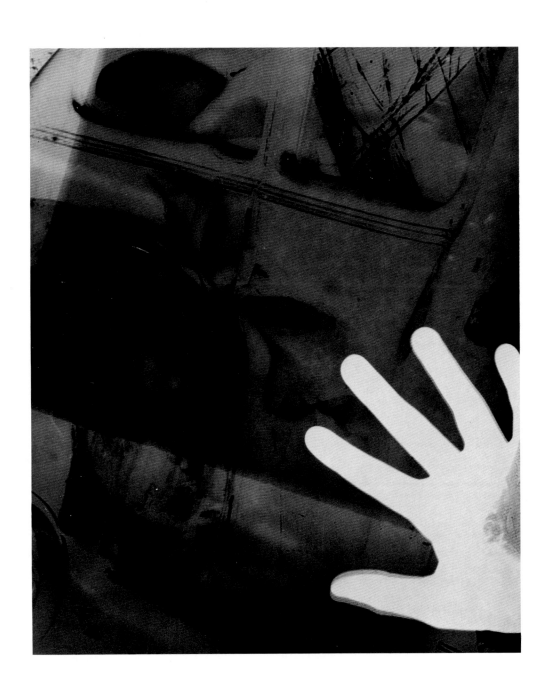

34 *GHOST OF THE ACCIDENT, 1978*

35 *CORN STALKS GROWING, 1945·© 1979*

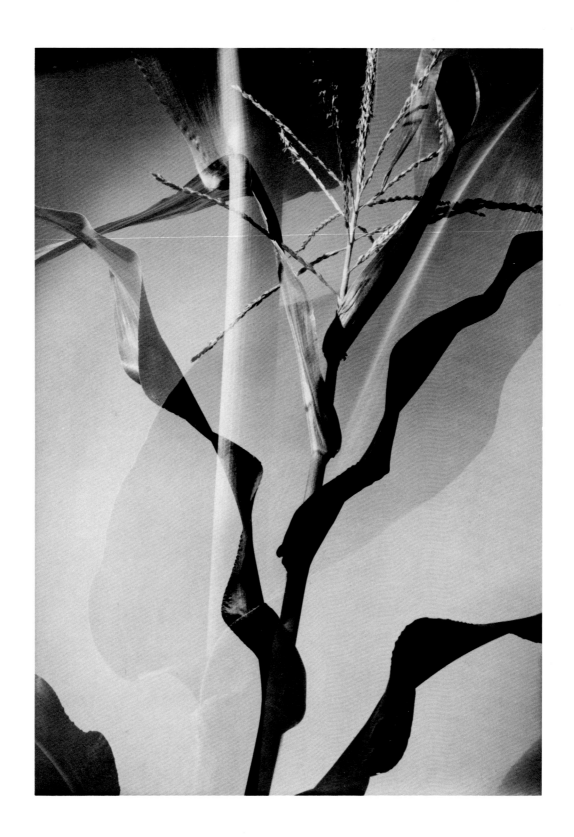

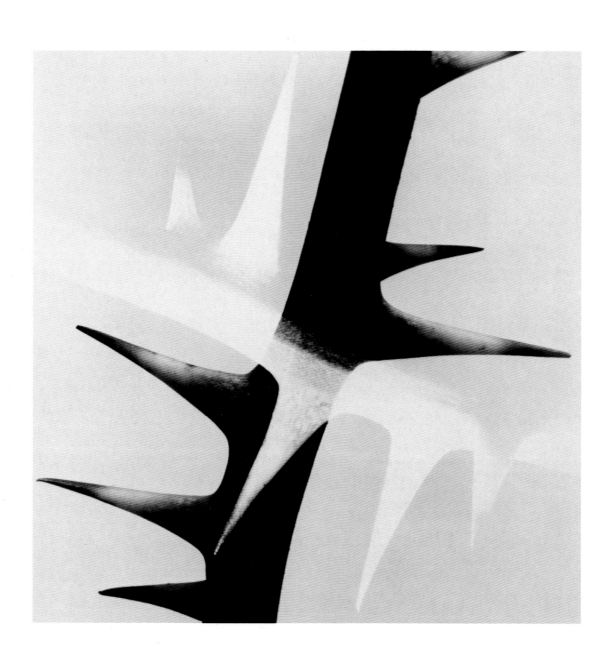

36 *BRIARLOCK, 1943-©1972 (negative, positive photomontage)*

37 *LEAF FLOATING IN CITY, 1972 (photomontage-photogram)*

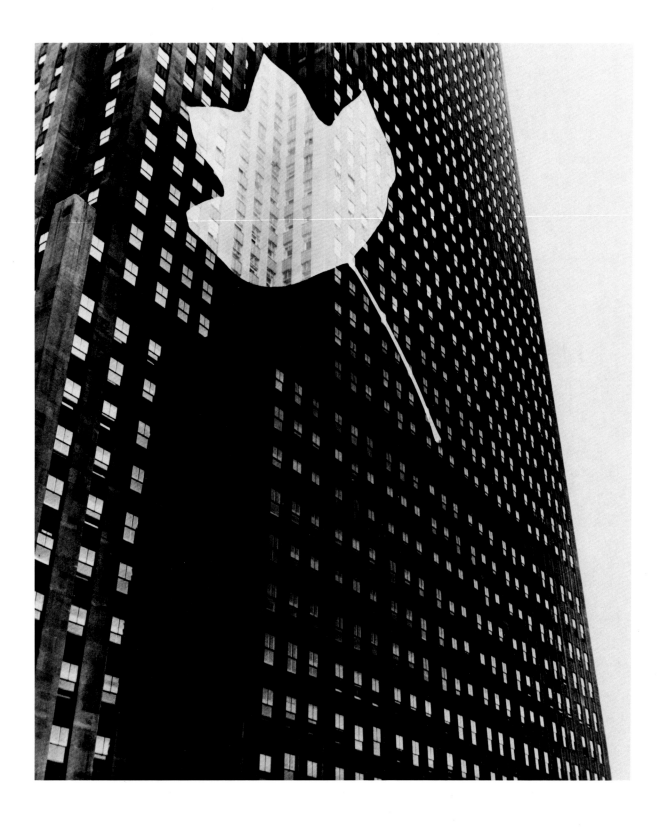

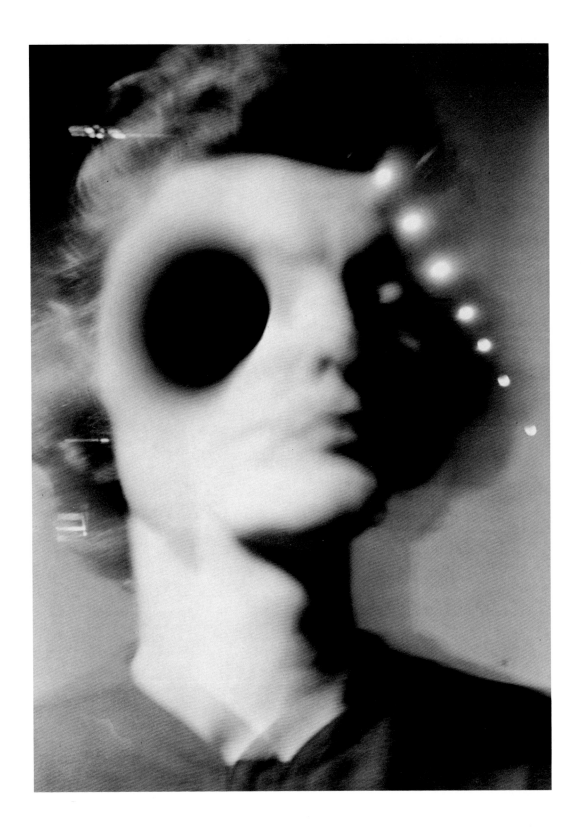

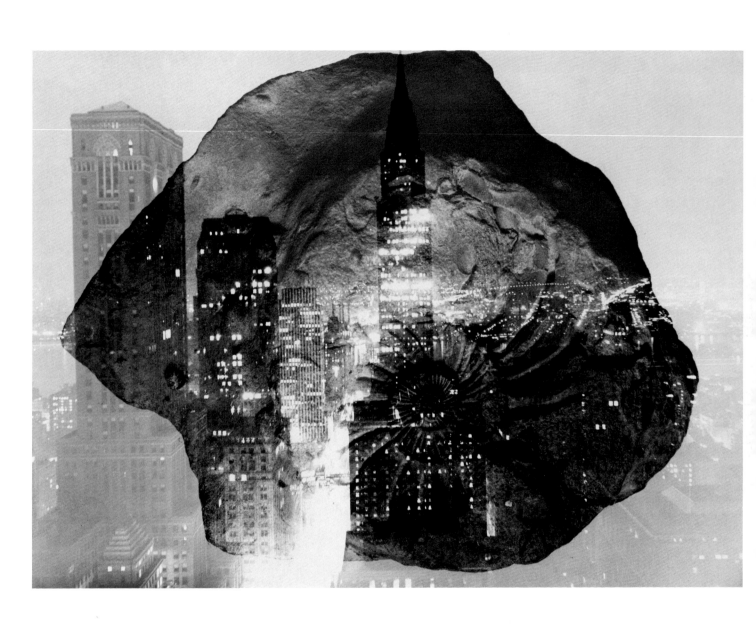

38 *BRAINWASHED, 1966-© 1969-II*

39 *FOSSIL IN FORMATION, 1965-© 1972*

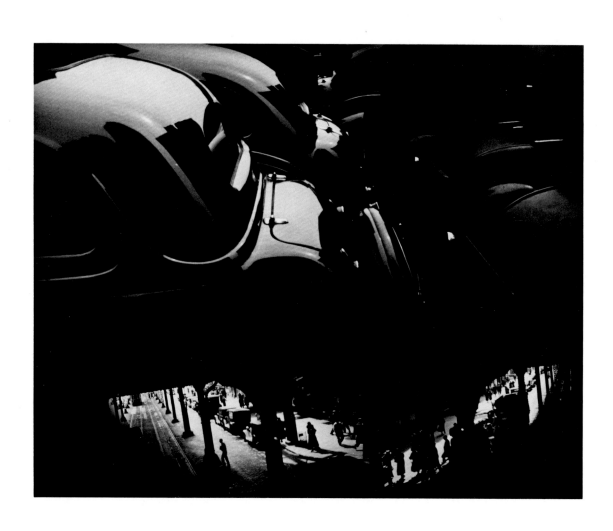

40 *THIRD AVENUE EL WITH CARS, 1939-©1972*

41 *INNER STRATAS, 1970 (reflective-photogram)*

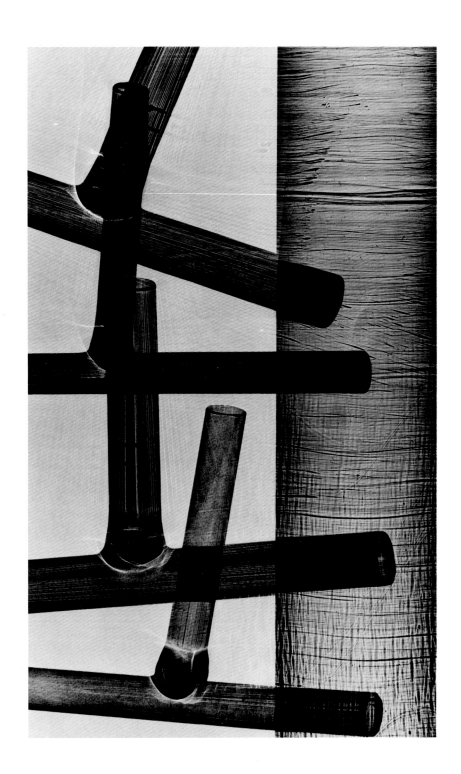

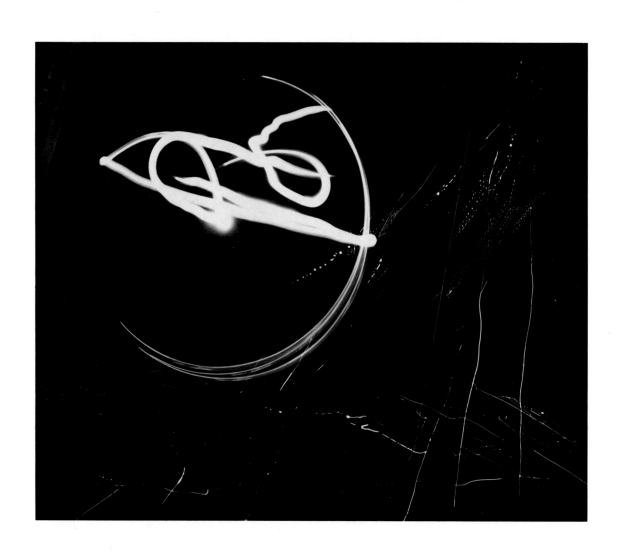

42 *ESP BREAKING THROUGH, 1969 (photogram-light drawing)*

43 *INCOMING, 1956-© 1978 (photomontage-photogram drawing)*

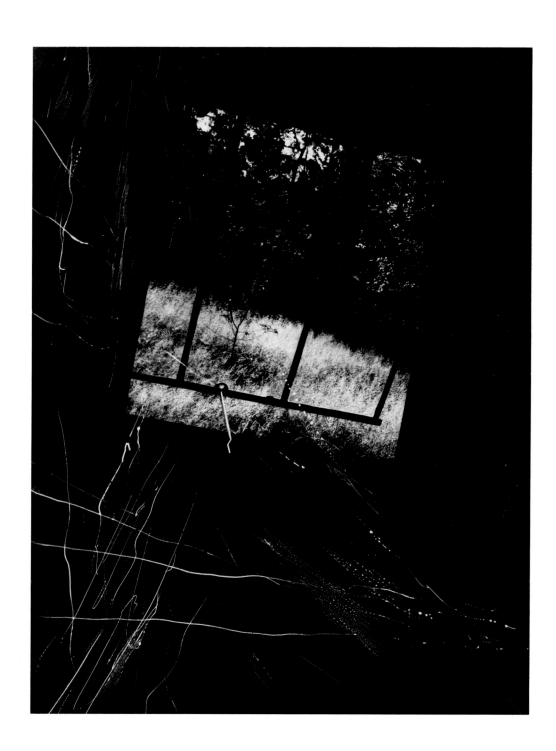

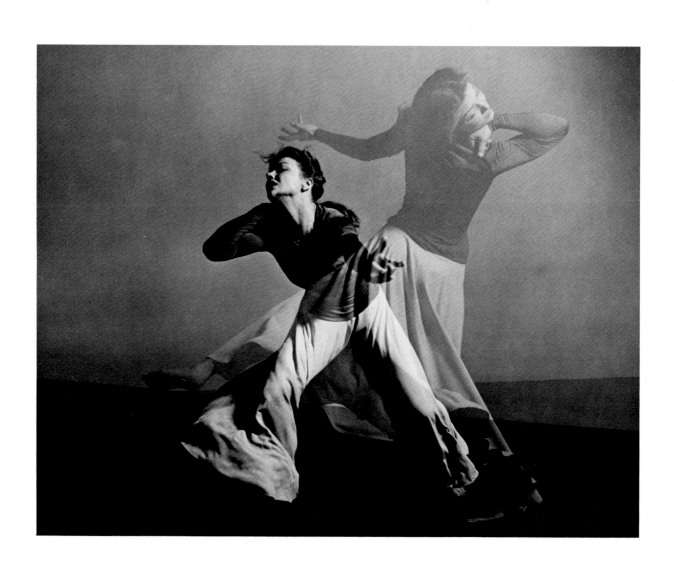

44 *VALERIE BETTIS: Desperate Heart-I, 1944-© 1972 (planned double image)*

45 *VALERIE BETTIS: Depserate Heart-II, 1944-© 1972 (planned double image)*

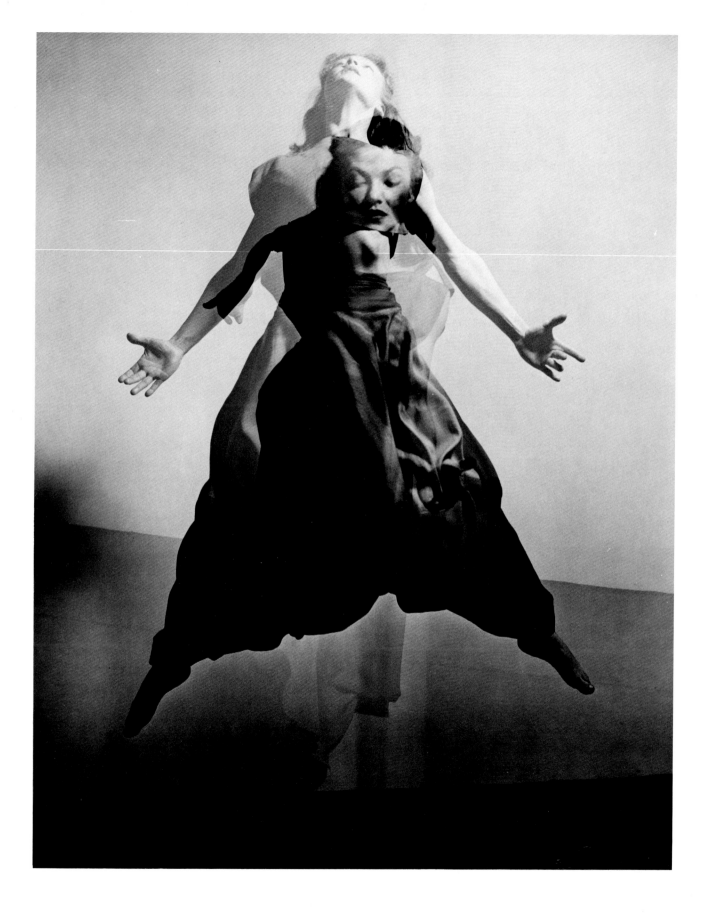

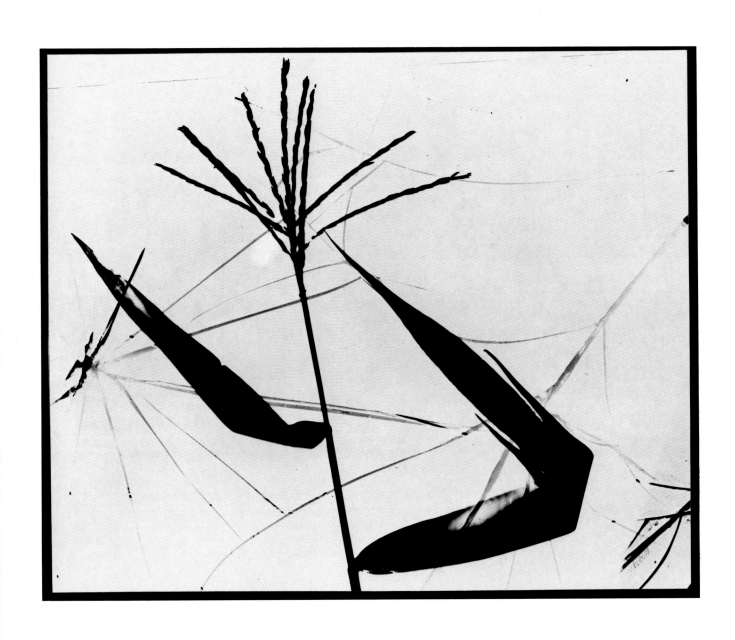

46 *CORN TASSEL THROUGH BROKEN WINDSHIELD, 1967*

47 *COMPUTERIZED MANHATTANITES, 1973*

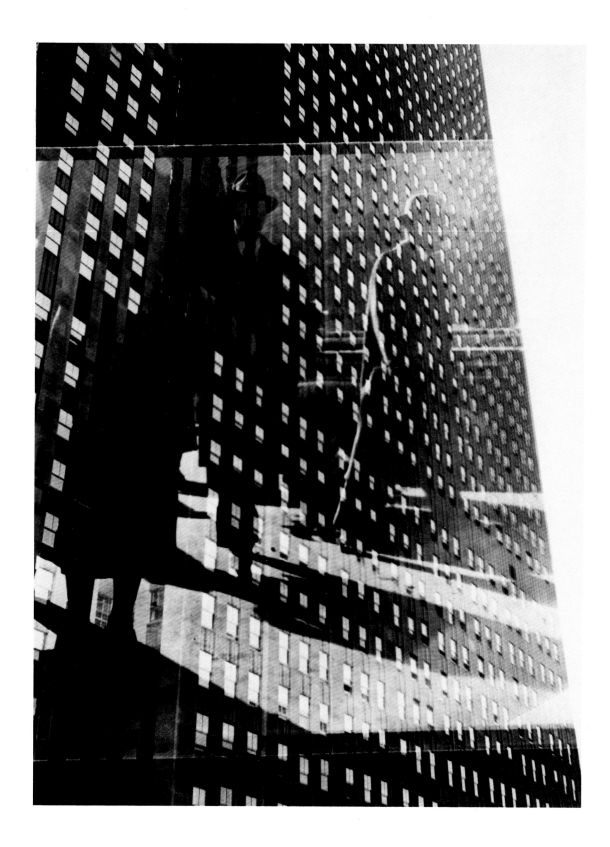

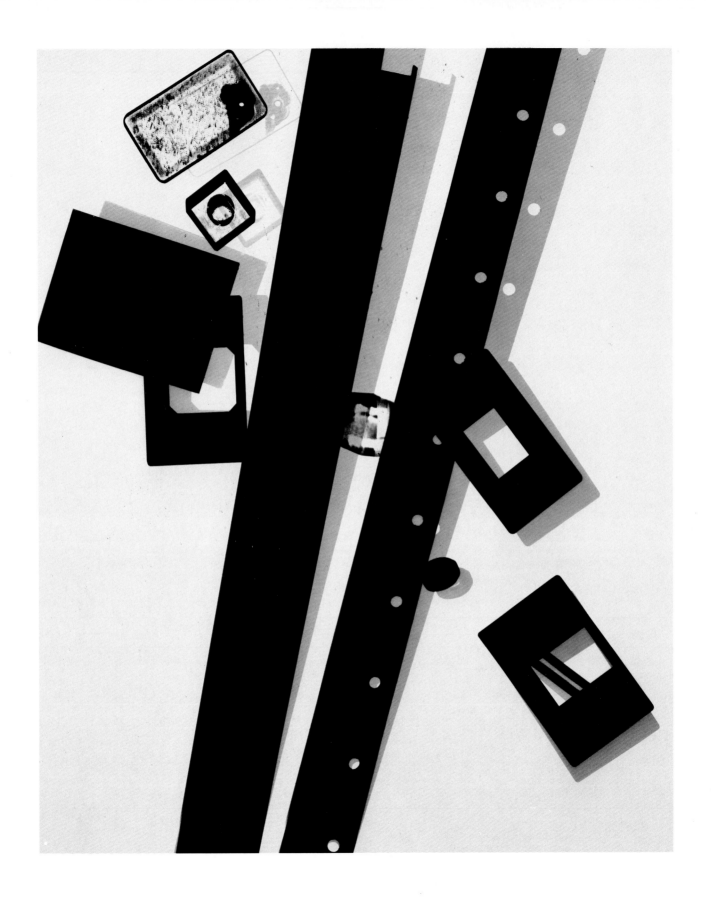

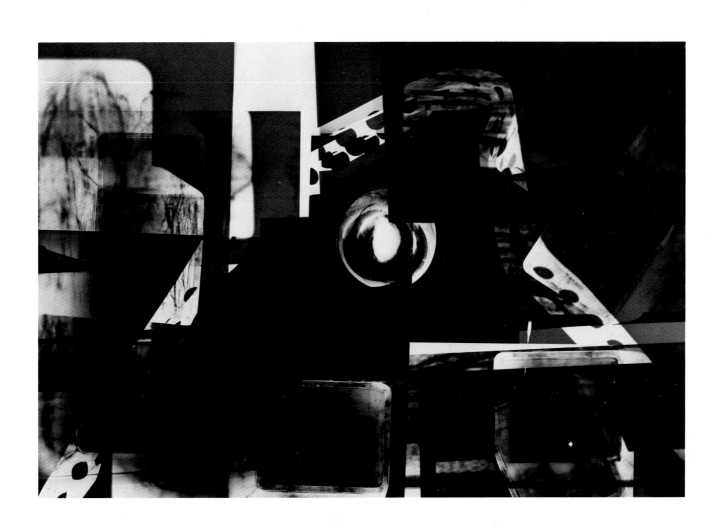

48 *LAYOUT, 1946-©1979 (shadow photogram)*

49 *OPACITIES, 1944-©1979 (serial-photogram)*

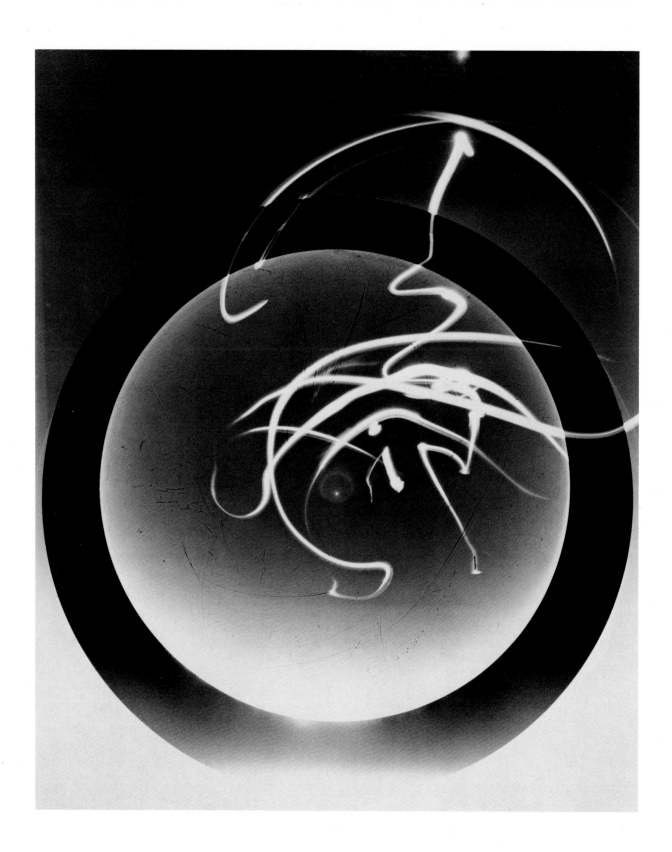

50 *COSMIC EFFORT-©1965 (photogram-light drawing)*

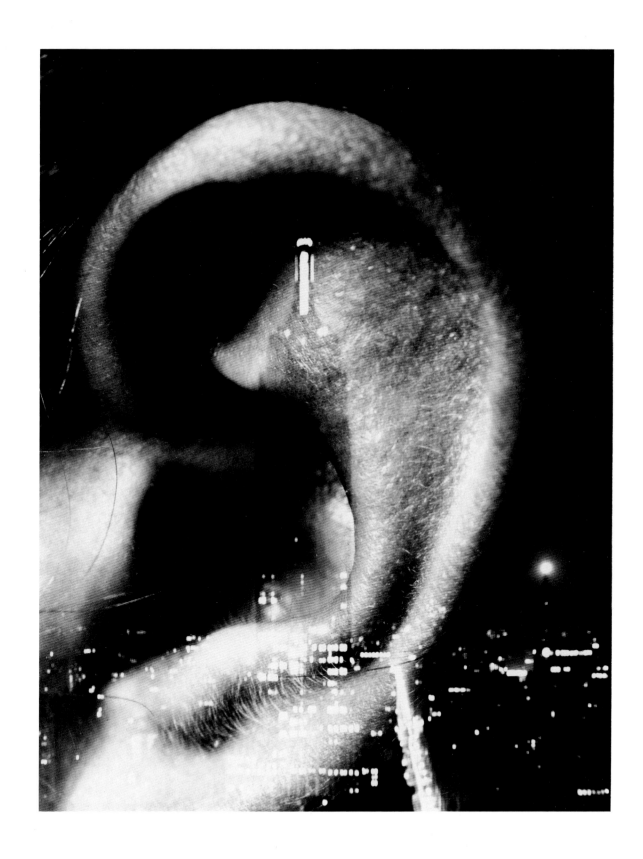

51 *CITY SOUND*·©1972

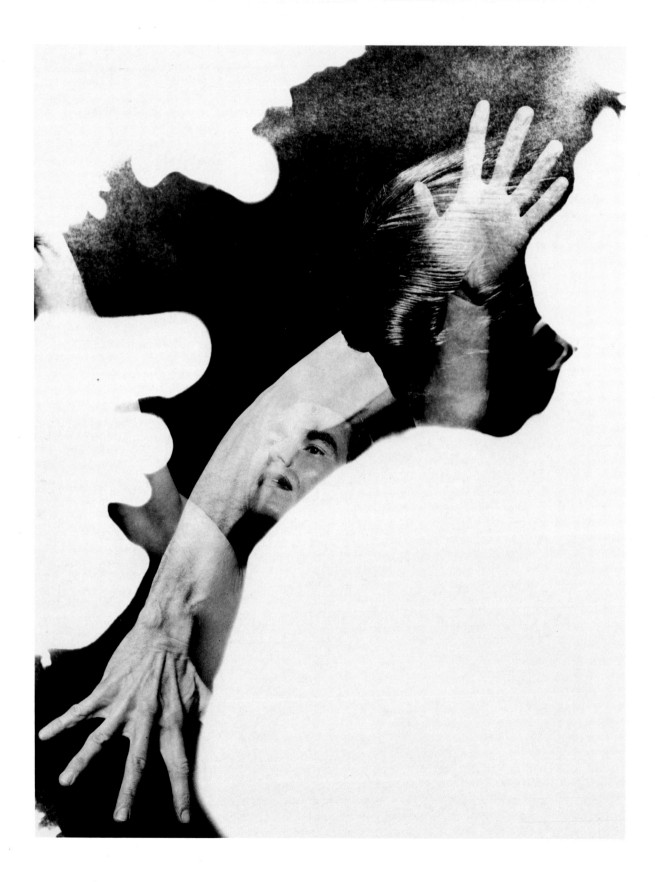

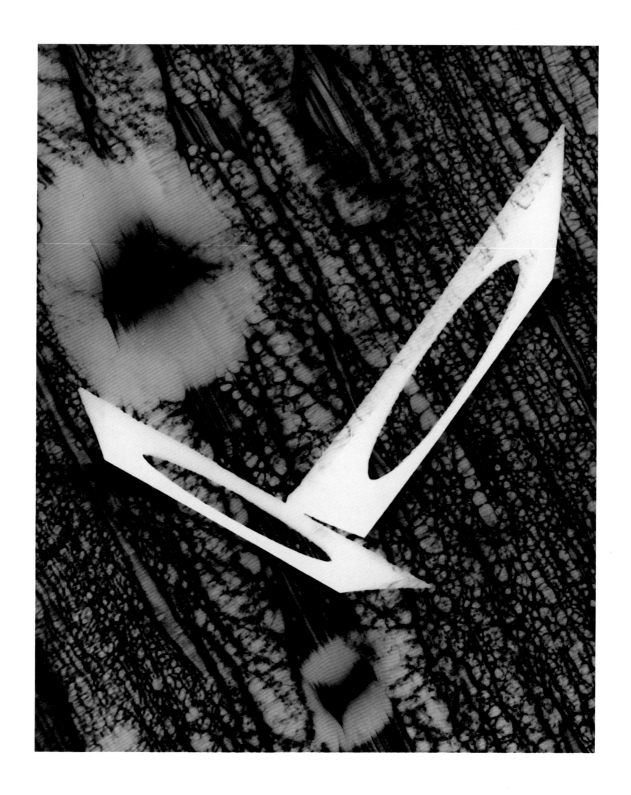

52 *SEARCHING·©1979 (photomontage-photogram)*

53 *YIN-YANG IN FLIGHT, 1956·©1979 (photomontage-photogram)*

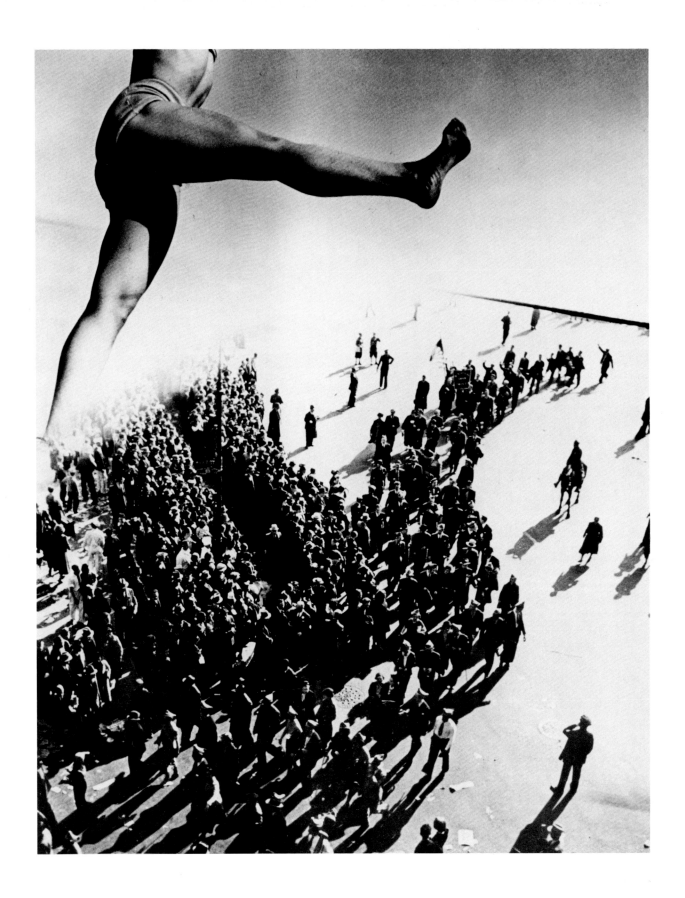

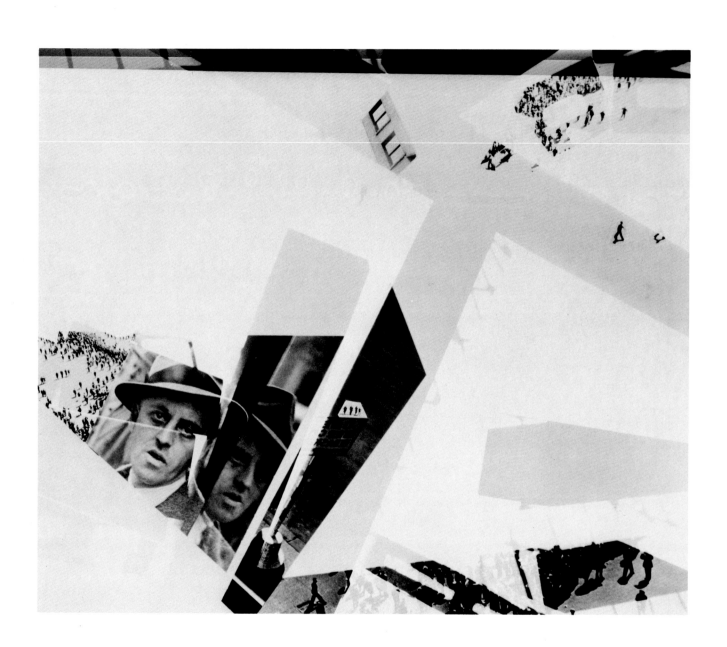

55 *USE LITTER BASKET, 1943-©1972*

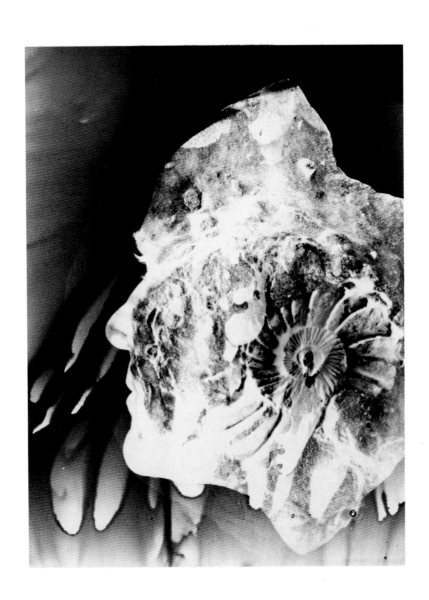

56 *NUCLEAR FOSSILIZATION-V, 1979*

57 *NUCLEAR FOSSILIZATION-I, 1979*

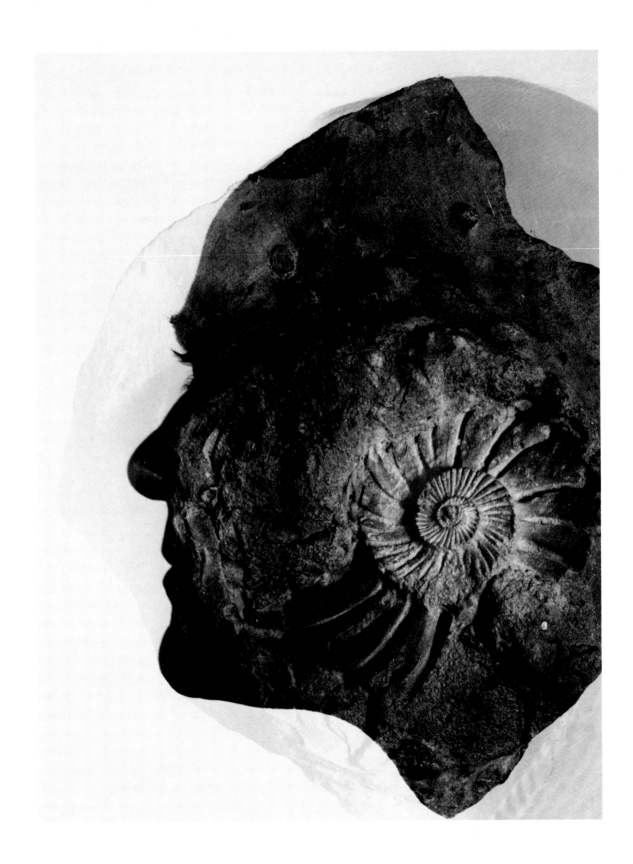

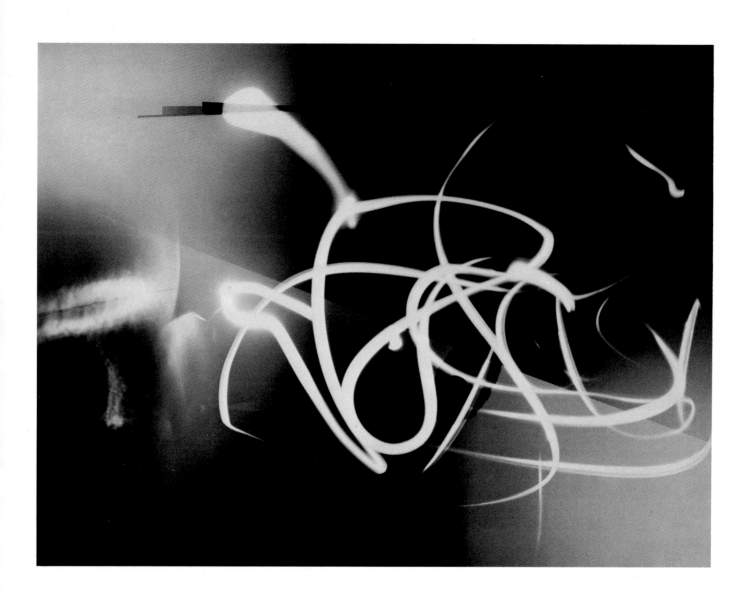

58 *SERPENT LIGHT-III, 1948-© 1979 (photomontage-light drawing)*

59 *ARTIFICIAL LIFE FROM THE LABORATORY, 1967-© 1972 (photomontage-light drawing)*

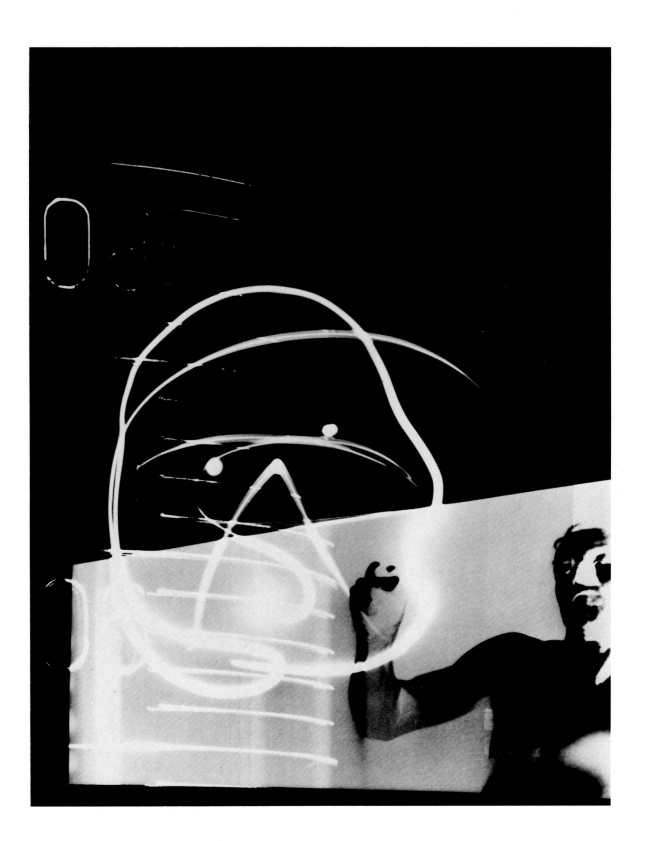

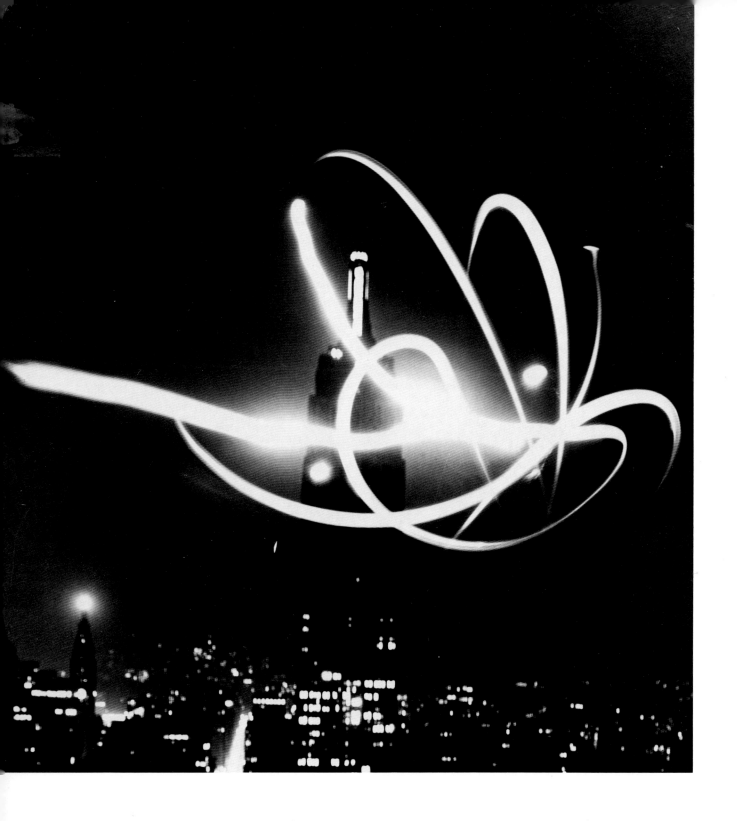

60 *UFO VISITS NEW YORK, 1965 (photomontage-light drawing)*

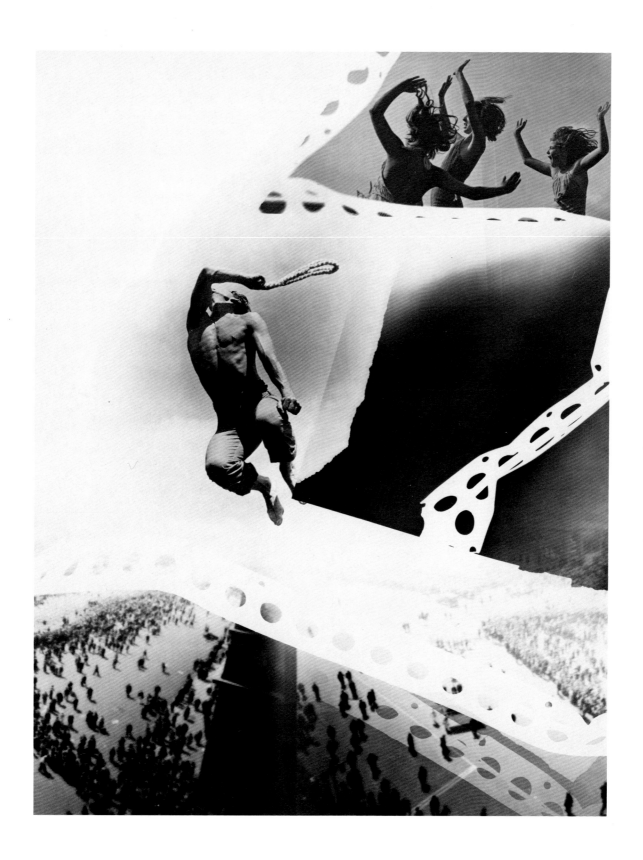

61 *HULLABALOO, 1959-*©*1979 (photomontage-photogram)*

SELECTED BIBLIOGRAPHY

BY BARBARA MORGAN

Books

MARTHA GRAHAM: Sixteen Dances in Photographs. New York: Duell, Sloan, and Pearce, 1941.
PRESTINI'S ART IN WOOD. Text by Edgar Kaufmann, Jr., Lake Forest, Illinois. Pocahontas Press, 1950.
SUMMER'S CHILDREN: A Photographic Cyle of Life at Camp. Morgan & Morgan, 1951
BARBARA MORGAN. Dobbs Ferry, New York: Morgan & Morgan, 1972.

Articles

"Photomontage." *Miniature Camera Work,* 1938.
"Photographing the Dance." *Graphic Graflex Photography,* 1940.
"Dance into Photography." *U.S. Camera,* December 1941.
"Dance Photography." *The Complete Photographer* 18:3, March 10, 1942.
"In Focus: Photography, the Youngest Visual Art." *Magazine of Art* 35:7, November 1942.
"The Scope of Action Photography." *The Complete Photographer* 10:4. March 20, 1944.
"Kinetic Design in Photography." *Aperture,* No. 3, 1953.
Essays contributed to *Encyclopedia of Photography,* 1953.
"Aspects of Photographic Interpretation." *General Semantics Bulletin,* 1963-64.
"Light Abstractions". *University of Missouri,* St. Louis, Missouri, 1980.

ABOUT BARBARA MORGAN

Articles

Etna M. Kelley. "Barbara Morgan: Painter Turned Photographer." *Photography,* September 1938.
Fritz Neugass. "Great American Photographers: Barbara Morgan." *Camera,* February 1952.
Beaumont Newhall. "Barbara Morgan, Summer's Children." *Magazine of Art,* March 1952.
Harold Lewis. "On Illustrating a Book. *Photography,* April 1952.
Helen Haskell, "Summer's Children: Life at Camp." *Living Wilderness,* Summer 1952.
Jacob Deschin. "Archival Printing—Push for Permanence." *Popular Photography,* August 1969.
Doris Hering. "Barbara Morgan: One of America's Great Photographers Reflects a Decade of Dance 1935-1945." *Dance Magazine,* July 1971.
Clive Lawrence. "An Explosion of Energy." *Christian Science Monitor,* January 13, 1973.
Anna Kisselgoff. "Interview with Barbara Morgan." *The New Times,* June 19, 1975.
Deborah Papier. "All the Atoms Are Dancing." *Washington Calendar Magazine,* October 1, 1976.
Casey Allen. "The Influential Photographs of Barbara Morgan." *Camera 35,* May 1977.
Diana Loercher. "The Essence of Dance." *Christian Science Monitor,* September 18, 1978.
Suzanne DeChillo, "Barbara Morgan: Photographer of the Dance." *The New York Times,* January 14, 1979.

SELECTED BIOGRAPHICAL NOTES

1900 Born in Buffalo, Kansas, July 8. (11th generation-American.)

1919-23 Student, University of California, Los Angeles; art major.

1925 Married Willard D. Morgan.

1925-30 Joined art faculty at UCLA. Taught design, landscape painting and wood cut. Painted and photographed in Southwest during summer vacations. Exhibited paintings and woodcuts in West Coast art societies. Informally studied theatrical lighting and puppetry. Met Edward Weston and realized photography as Art.

1930 Moved to New York City. Traveled for Willard Morgan's Leica lectures.

1931 Established studio in New York. Exhibited paintings in New York galleries. Exhibited graphics, Weyhe Gallery. For art study: photographed Barnes Foundation Art collection.

1932 Son, Douglas, born.

1934 One-person painting and graphics exhibition, Mellon Gallery, Philadelphia.

1935 Son, Lloyd, born. Turned to photography.

1935-41 Exhibited photographs: City themes, photomontage, dance, children, light drawings.

1940-43 "Dance Photograph Touring Exhibitions, I, II, III, IV," circulated to over 150 colleges, museums and galleries.

1941 Book published, *MARTHA GRAHAM: Sixteen Dances in Photographs*. Received American Institute of Graphic Arts Trade Book Clinic Award.

1941 Moved to Scarsdale, New York.

1945 U.S. State Department, Traveling exhibit; AMERICAN MODERN DANCE, prepared for Inter-American Office of National Gallery of Art, for Latin American circulation.
 Portuguese version shown at United Nations Conference, San Francisco at first formative session.
 Spanish version exhibit—Museum of Modern Art, N.Y.C.

1955 Continuing photographic projects and exhibits, designed and picture-edited book: *The World of Albert Schweitzer* by Erica Anderson and Eugene Exman.

1959 Art-Archeological trip to Crete, Greece, Spain, Italy, France, and England.

1961 One-person exhibition, painting and graphics, Sherman Gallery, New York.

1967 Willard Morgan died.

1970 Elected a Fellow of the Philadelphia Museum of Art. Exhibit at Smithsonian Institute, Washington, D.C.

1972 One-person exhibitions: Museum of Modern Art, New York; Amon Carter Museum of Western Art, Fort Worth, Texas; Focus Gallery, San Francisco, California.

1973 One-person exhibition, Pasadena Art Museum, California.

1974 One-person exhibition, Institute of American Indian Art, Sante Fe, New Mexico. Participated in exhibition, Whitney Museum of American Art, New York.

1975 Received grant from National Endowment for the Arts. Participated, "Women of Photography: An Historical Survey" exhibition, San Francisco, California.

1976 Participated, "200 Years—America on Stage" exhibition, J.F. Kennedy Center, Washington, D.C.

1977 Created *BARBARA MORGAN DANCE PORTFOLIO*. One-person exhibitions: Gallery at Hastings-on-Hudson, New York; Marquette University, Milwaukee, Wisconsin; University of Nebraska, Lincoln, Nebraska.

1978 Received honorary Doctorate of Fine Arts, Marquette University, Milwaukee.

1979 One-person exhibitions: Ohio University College of Fine Arts; PHOTOMONGAGE EXHIBIT, George Eastman House, Rochester, New York; Baldwin Street Gallery, Toronto, Canada.
RECOLLECTIONS: Ten Women of Photography. International Center of Photography, New York.

1979 National Conference of the Society for Photographic Education, Barbara Morgan honored quest photographer, Fort Worth, Texas.

1980 Group exhibit, *LIGHT ABSTRACTIONS*, University of Missouri, St. Louis, Missouri.

1980 Vision Gallery, Boston, Massachusettes.

1980 Group exhibit, Whitney Museum of American Art, New York (Downtown Branch).